Hunters of the Eastern Forest

D1712242

by

R. Stephen Irwin M.D.

Illustrations by J.B. Clemens

hancock
house

ISBN 0-88839-175-7
Copyright © 1984 R. Stephen Irwin, M.D.

Printed in Canada by: Friesen Printers

 Published simultaneously by

Hancock House Publishers Ltd.
19313 Zero Avenue, Surrey, B.C., Canada V3S 5J9

Hancock House Publishers Ltd.
1431 Harrison Ave., Blaine, Washington, U.S.A. 98230

Contents

The Series

The NATIVE HUNTER SERIES by Dr. Stephen Irwin, is taken from his major treatise

THE PROVIDERS:
Hunting and Fishing Methods of North American Natives,

from the same publisher. Many persons helped Dr. Irwin in his years of research and they are appropriately acknowledged in that major work. Similarly, an extensive bibliography is given in THE PROVIDERS.

Introduction

Until 10,000 years ago, essentially every earthling survived by hunting. By the time of Christ, 8,000 years later, only half of the human race was dependent on hunting and this number continued to dwindle until the last 300-400 years when only isolated pockets of hunting cultures existed around the world. There was a worldwide trend towards an increasing dependency on horticulture, particularly in the more temperate climates. In spite of this, of the approximately 80,000,000,000 humans who have ever lived on earth to date, 90% survived by hunting. (The word hunting here is used in the broadest sense to include fishing and trapping.) It seems inconsistent that such little is known about the technology of the economy that has been vital to the bulk of humanity. There is a lack of information on hunting, fishing and trapping techniques among hunting cultures of the last two centuries that were available for study. While the literature is replete with descriptive accounts of primitive art, social structure, mythology, linguistics, etc., apparently many early ethnographers found daily working routines essential for survival too mundane to record.

The Providers and the *Hunter Series*, is an attempt to record and to illustrate the hunting, fishing and trapping methods of the Indians and Eskimos of North America.

If some of the methods described in this book seem cruel or barbaric, we must remind ourselves that our own society is no less savage. Advanced technology may allow us to be more discreet in our slaughter, and it may be performed by proxy using select executioners, but our requirements for survival are no different from those of the native Americans. We, like they, must continue to provide.

Appearance of Man in North America

North America was once a continent that had never known man. Then at some unrecorded moment, at a time that is almost unimaginably long ago, the New World first felt the tread of a human foot. These intrepid wanderers became the first Americans. They were primitive big game hunters from Siberia, gaining access to the North American Continent by the way of Bering Strait, between 25,000 and 40,000 years ago.

It was in the Old World, specifically in Africa, where man evolved. Much later, he migrated into the New World. That Bering Strait is the most likely location for this migration has been substantiated by considerable archaeological evidence, and the feasibility of such a feat is apparent if one consults a map of the area. Only 56 miles (90 kilometers) of water separate the continents of Asia and North America at Bering Strait; even this expanse of water is broken up in the middle by the Diomede Islands.

Today, such a distance would not make a very impressive boat trip, but it is doubtful that these primitive hunters had a craft capable of even this meager voyage. During the Ice Age, when the first crossings occurred, so much of the earth's water was impounded in polar ice caps or glaciers that the level of the oceans was lowered. This resulted in an isthmus connecting Siberia and Alaska. Even if these ancient hunters did not walk dry-shod over this spit of land, they certainly could easily have crossed over on the winter ice. In historical times, there was considerable contact and interchange between Eskimos on the Alaskan side and the Siberian side.

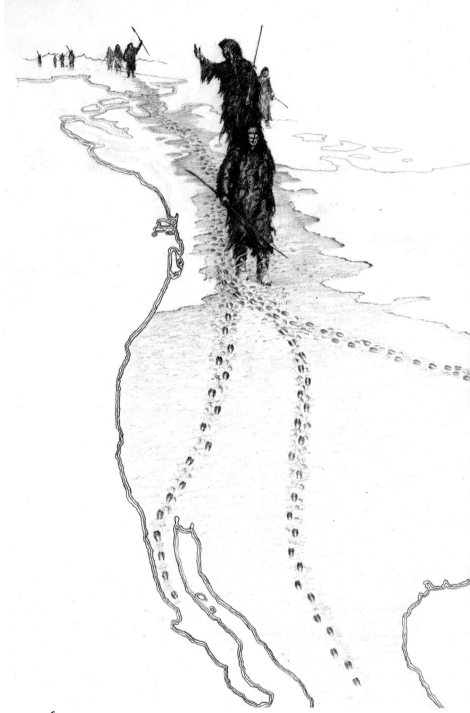

Various animals, many of which are extinct today, also made this crossing. Indeed, it was primarily the wanderings of such animals that lured these early nomadic hunters into the New World — not pioneering zeal. It should be emphasized that there was not just a single isolated crossing of Bering Strait by a group of humans. Rather, there were successive waves of human beings over a period of perhaps several thousand years.

These primitive hunters, after reaching the New World, travelled through the Yukon and Mackenzie River valleys, followed coast-lines and sought mountain passes.

The earliest inhabitants of North America crossed the Bering Land Bridge from Siberia and followed game trails through the ice-free corridor to lands in the south.

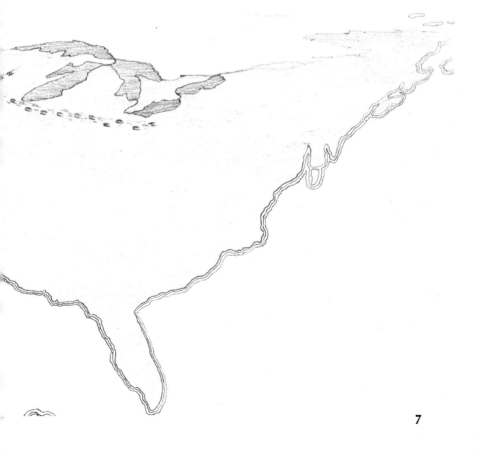

The continental ice sheet, a great glacier that spanned North America from sea to sea and stretched a thousand miles to the south, presented an imposing barrier to early migrants in their southward movement. Miraculously, there did remain an ice-free corridor, almost as if designed as a migratory aid to lands in the south. Actually, two separate ice sheets mantled the northern latitudes. The Laurentide Ice Sheet covered most of Canada east of the Rocky Mountains. A much smaller ice sheet, the Cordilleran, centered on the Rockies, and spread westward to the Pacific. The corridor formed between these ice sheets must have been an inhospitable area with its icy winds, driving snow, and frequent blinding fogs. Still, grazing animals entering the corridor would have been sufficient stimulus to lure these brave hunters onward. Eventually man inhabited most of the North American and South American continents. French prehistorian Francois Bordes has noted that not until man occupies another planet will he have such a vast virgin domain to explore. No special instinct guided the travels of primitive man, nor was there any particular reason why their migration was in a general southward direction. In fact, these hunters' ancestors initially had traveled generally northward to reach the Bering Land Bridge from Siberia. The only direction the early hunters followed was that of the game trails that lured them on at random; no doubt some bands even followed game trails that wandered back to Asia. Beyond the present trail there was always the horizon with its possibility of better hunting and perhaps a milder climate.

The Stone Age hunters who pursued the giant land mammals of their day are referred to by archaeologists as "Paleo Men," and their period in time is called the "Paleolithic Period." This is in contrast to the "Archaic Culture" and "Archaic Period" that includes the more modern Indians and Eskimos. The period of transition

between the two cultures was very gradual, but for reference purposes has been arbitrarily set at 4000 B.C. The main factor bringing about this transition was the extinction of the giant land mammals which necessitated a whole new means of existence — one based more on gathering and later on horticulture.

How the Paleo Hunters existed has been laboriously pieced together from shreds of archaeological evidence, and much of their way of life still remains clothed in romantic supposition. The ancient hunter wore robes of fur, probably knew the use of fire, and carried stone-tipped spears to even the odds against the huge mammoths and other game he hunted.

To Stone Age hunters, the pursuit of big game was almost a form of warfare, where the hunted animal was an adversary whose death was necessary for the hunters' survival. Failure to kill these behemoths meant that privation and death would certainly follow. Stone Age big game hunting was a risky business, and the tables could turn rapidly, with the hunter suddenly becoming the hunted.

The animals primitive man hunted were the hairy and imperial mammoths, ancient camels and horses, sabre-toothed tigers, the long-horned bison (Bison antiquus), which was an ancestor of our American Bison (Bison bison) and rarely the flat-skulled mastodon. These animals were colossal; the commonly hunted mammoth stood more than thirteen feet (4 meters) at the shoulders and carried sixteen-foot (5 meter) tusks. The mammoth was a herbivore, and at one time grazed over most of the North American Continent.

Paleo hunters lived, hunted, and traveled in small bands of family groups. For the most part, they camped in the open and did not show the preponderance for cave dwelling that their European ancestors did, although there were exceptions. Camp would be made where game

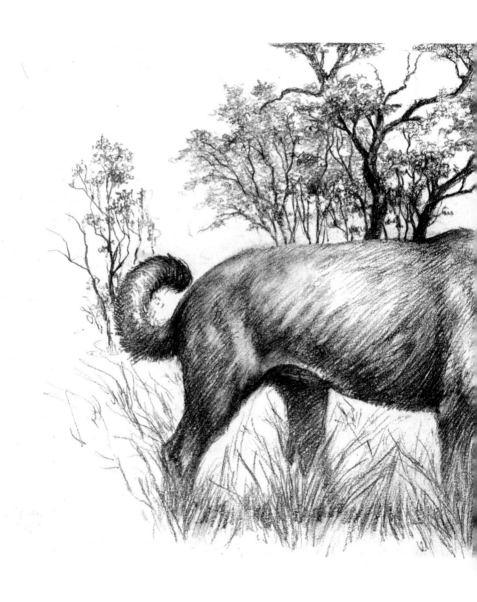

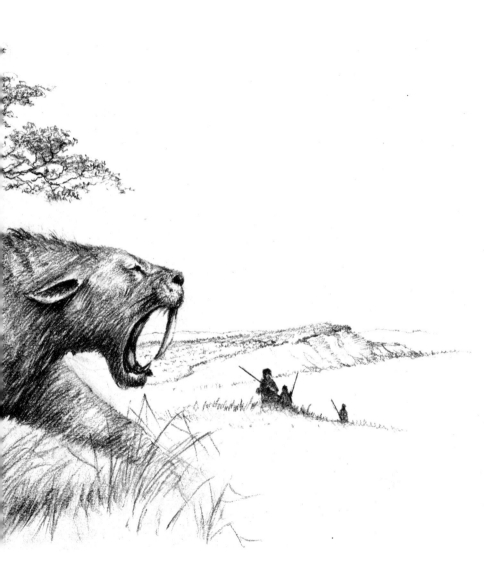

The sabre-toothed cat, now extinct, was hunted by paleo men.

animals fell and when the meat was gone, or no longer good, they would move on. The main occupation these hunters engaged in, perhaps the only one they even knew about, was the grim business of survival through hunting.

As hunters, Paleo Men were opportunists in the most extreme sense. They would patiently skirt the perimeter of a herd, as did other predators, waiting for the right moment when a strayed calf or a weak adult would become

The long-horned bison (*Bison antiquus*) **was an ancestor of our present American bison** (*Bison bison*).

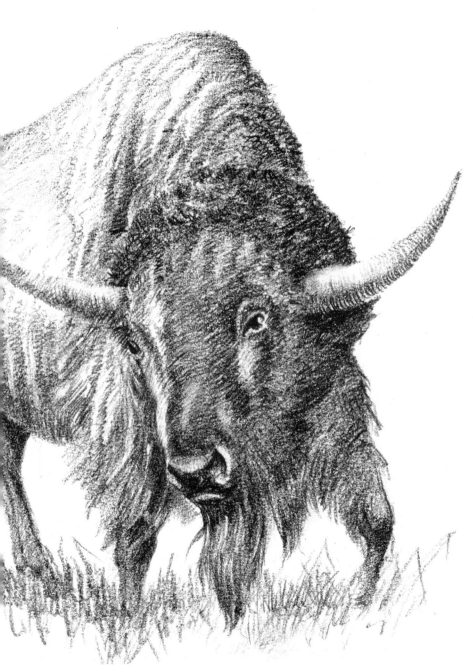

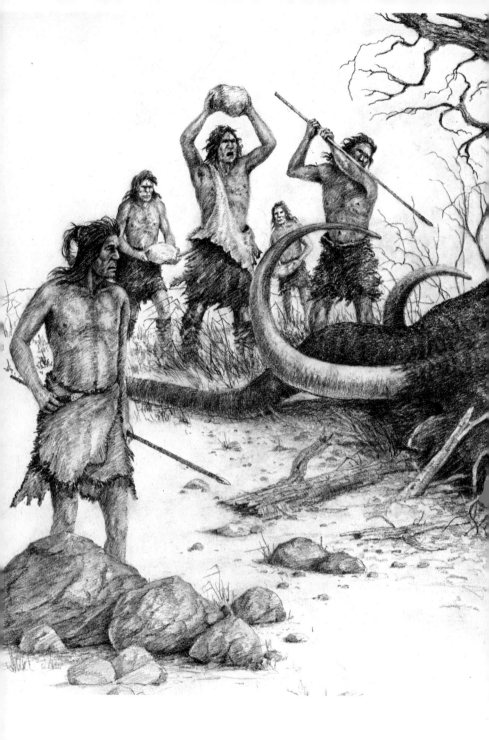

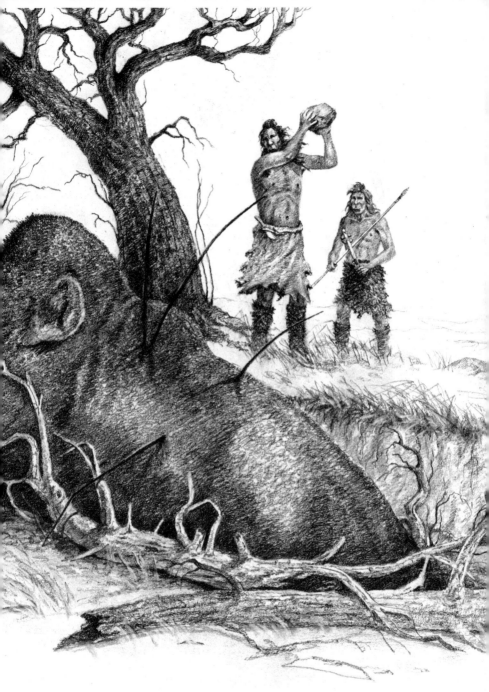

A group of Paleo hunters subdue a mammoth with spears and stones.

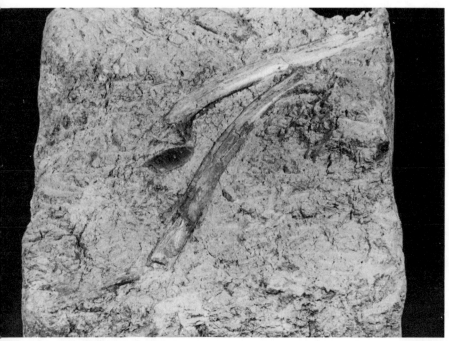

Denver Museum of Natural History

During an excavation in 1927, this Folsom point was found in situs among the bones of the now extinct *Bison antiquus figginsi* in New Mexico. The landmark discovery extended our knowledge of man in the New World by several thousand years.

separated, and could be ambushed. Natural traps such as boggy waterholes were taken advantage of to limit the movements of a flustered or wounded animal, and thus make the kill easier. Death would come slowly to such large animals, and it would take repeated spear thrusts and pounding with rocks and clubs to complete the task. When traveling through mountainous country, Paleo Man never failed to check fresh snow slides or avalanches where there would be a good chance of game being entrapped and frozen.

These first hunters left few traces of their ways of life. Human remains are almost non-existent; what few fragments have been discovered have posed more questions than they have provided answers. We know of these hunters mainly from their distinctively-shaped stone spear points that have been found with the bones of some of the long-extinct mammals. The dates of existence of many early land mammals are fairly well documented, and spear points, when found in association with them, can be similarly dated. One of the earliest and most famous discoveries of points unearthed with a "kill" made by a Paleo hunter occurred near Folsom, New Mexico in 1926. A cowboy, out looking for strays in a steep-walled arroyo, happened to notice a few old bones sticking out of an eroded bank. Poking curiously among these bones, he found a strange-looking, slender, fluted spear point. This chance discovery produced for the scientific community the bones of twenty-three long-horned bison and several fluted points later named Folsom in honor of the nearby town. The beasts had been driven into a box canyon with no avenue for escape, killed, and butchered.

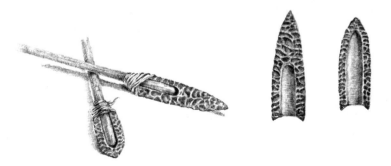

Folsom points characterized by their distinct flake scar are among the earliest spear tips used by man on the North American Continent.

It has been accurately stated that the greatest portion of the history of human existence on earth is written in flint and bone. The lot of the archaeologist has been to tease from an unrelenting earth shreds of evidence buried beneath the sediment of ages, and to painstakingly piece this history together.

Folsom and Clovis points are the earliest of ancient spear tips. The Clovis type probably predates the Folsom type, and is shaped somewhat differently. Both Folsom and Clovis points are amazingly well formed and technically advanced for such an early time in pre-history. They are fluted on each face, presumably to better fit the spear shaft. Depending on the locale, agate, chalcedony or flint were favored materials. Points were formed by a method known as pressure chipping — a rather unexpected technology for this early date. Fortunately, from an archaeological standpoint, Clovis and Folsoms are quite distinctive in form with their flute or flake scar running from the base partway to the tip. The unique appearance of these points has made them readily identifiable, a characteristic which has aided in their being traced all the way to the backdoor of the New World — the area around Bering Strait in Alaska.

Each discovery of a rare Folsom or Clovis point, be it by a professional archaeologist or by a casual weekend hiker who reports his find, adds another piece to a large and complicated puzzle. It should be emphasized that the West is not the sole domain of Paleo Man, although the most productive sites are here. Indeed, numerous fluted points resembling the classic Folsom and Clovis types have been found throughout the Midwest and East. The problem has been that the wet, humid eastern woodlands have not preserved decayable material as have the dry, western deserts. Finds have been largely on the surface, and not in undisturbed strata or in association with animal bones. Still, the inference that must be drawn from the finding of these midwestern and eastern fluted points is that Paleo

Man eventually spanned our continent from coast to coast. The best estimates are that the first crossings into the New World occurred about 40,000 years ago or sooner. Folsom points found in New Mexico have been dated at 15,000 years of age. Thus, it is not illogical to deduce from these dates that the gradual southward migration of these people took 25,000 years to occur. Their progress was undoubtedly sporadic. Movement within each ecological zone might have been fairly fast. Encountering a new zone, however, would have entailed a slowing of the migratory spread to allow new adaptive patterns and survival techniques to evolve. This pattern can be seen in the Eskimos who were relative late-comers on the North American scene arriving about 6,000 years ago. They rapidly inhabited the entire Arctic coastline from Alaska to Greenland. So swiftly did this spread of inhabitation occur that their language did not experience regional variations and remained virtually the same across the top of the world.

Man came to North America during a period referred to as the Pleistocene on the paleontological time table. More commonly called the Ice Age, this was the period when the great land mammals roamed the continent. By now, the dinosaurs had long been extinct for reasons still not completely understood, although climatic changes may have been responsible for the demise of these awesome behemoths.

The ice age was a time of heavy rainfall, and the land of the Paleo hunters was dotted with lakes and ponds. As the glaciers retreated to the north, these lakes which had been fed by the glacial melt dried up, and the country became quite arid. Unlike the dinosaurs that preceded him, and even the large land mammals that he hunted, man, with his superior intelligence, was able to adapt — and to survive.

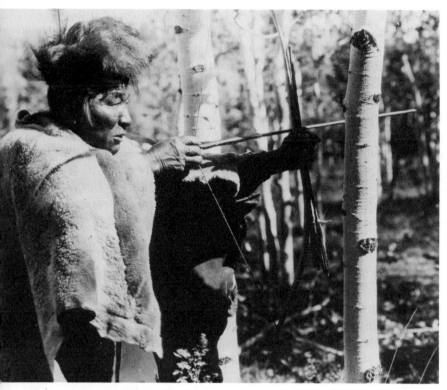

An Assiniboine hunter takes careful aim with his bow.

Hunters of the Eastern Forests

The great eastern hardwood forest was a marvelous wilderness before it was transformed by axe and plow, and became a sacrifice to the goddess of technical civilization and progress. Beech, basswood, maple, American chestnut, elm, wild cherry and ash covered the great area north of the Mason-Dixon Line from the Mississippi River to the Atlantic Coast. In this great forest, deer, black bear, eastern cougar and wild turkey thrived. This was the land of the Eastern Woodland Indian Culture with tribes, or nations, such as the Miami, Illinois, Huron, Potawatomi and Delaware. The culture area ascribed to the Eastern Woodland Indians goes beyond the deciduous hardwood forests of the eastern United States, crosses the transition forests of scrub oak and pine, and includes the coniferous forests of southcentral and southeastern Canada. Here, in a land of pine and birch, is the home of the Chippewa, Fox, Sauk, Menominee, Winnebago and Ottawa — all a part of the Eastern Woodland Culture.

The Woodland Indians have never sparked interest in the manner of the Sioux, Blackfoot, Crow and other Western Plains tribes. Nor have native art aficionados been interested in Eastern Woodland items as much as they have in the pottery of the Pueblos or in Navajo rugs. Perhaps most public familiarity with Woodland Indians is through the *Leatherstocking Tales* of James Fenimore Cooper or Longfellow's *Hiawatha*.

Being the first to greet settlers entering the new world, this culture was also the first to be introduced to smallpox, tuberculosis, alcoholism, and other scourges of the whiteman. The acculturation of Woodland Indians into white society was so rapid and complete that a shortage of good

descriptive accounts of life before the whiteman has resulted.

Indians of the Eastern Woodlands were semi-nomadic; although they maintained permanent villages, seasonal cycles still necessitated frequent movement. They successfully raised corn, beans and squash, and gathered nuts, berries, wild rice, and maple sugar. Such horticultural-gathering practices were the primary means of subsistence. Hunting and fishing were supplementary to the natives' food quest, although these, too, were of great importance. The Indians of the Eastern forests were about the most accomplished outdoorsmen the world has ever known.

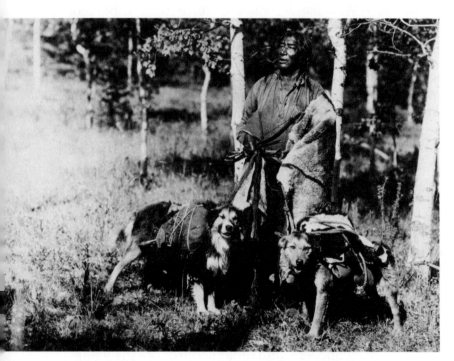

Smithsonian Institution

The Assiniboine, like most Eastern Woodland tribes, were semi-nomadic. Here a hunter uses pack dogs to enhance his mobility.

The hunters of the Eastern Woodlands were expert at deciphering all that had transpired on the forest floor.

The silence and stealth with which they stalked their prey has become part of the American Legend. They could make themselves almost invisible among their surroundings and move in ghost-like fashion along a game trail. Their spear or bow was ever-ready for immediate action, and they could freeze into immobility, remaining motionless for long periods of time if necessary. Patience was perhaps the deadliest of their weapons. They hunted in almost total silence. Even when they sat about the campfire and talked of their hunting exploits, they did so in a low tone of voice as if the animals were listening. A lifetime of attention to details in the wilds enabled them to determine if a set of tracks were left by a male or female, how large the animal was, how fast it was traveling, and how long ago it had passed. Clues might consist of overturned pebbles, minor depressions in leaf cover or grass, snapped twigs or other miniscule disturbances on the forest floor. An occasional speck of blood or soft dropping was a bonus find. Though this might all seem like magic to the modern Nimrod, their system was based on total logic.

Big Game Hunting

The primary weapons of the Eastern Woodland Indians were bows and arrows and spears. Of the two, certainly spears have the greatest antiquity. The hand-thrown spear became an entirely different weapon with the advent of the spear thrower or *atlatl*, as they were called in Central America. The story of the origin of this device has been lost through the ages, but they were definitely used throughout the Americas. Called throwing boards in the Arctic, and differing in design from those used farther south, they existed in the north country until well after white contact. Elsewhere, they were gradually replaced by the more sophisticated and effective bow and arrow. Carved antler tips that served as the hooked ends on atlatls are not rare archaeological finds in the eastern United States, attesting to their use by Woodland Indians. Typically having handles made of wood, and a tip of bone or antler, atlatls were approximately 18 inches (46 centimeters) in length. The antler or bone end-piece had a small projection designed to fit into a recession in the butt of the spear. The atlatl was retained in the hand as the spear was thrown, but greatly increased its velocity by lengthening the radius of the casting arc of the thrower's arm. With the addition of the atlatl, the hand-thrown spear became an effective, lethal weapon.

Like atlatls, bows were present throughout the North and South American continents when white men first arrived. Their lengths, styles, construction and capabilities varied greatly from area to area. Such differences, plus a wide geographical dispersion of bows and arrows, make the theory of several scattered and independent inventions of the weapon quite plausible. Bows used by Woodland Indians were, for the most part, longer than those used in

other parts of the country. Hickory and white ash were the preferred bow woods although hop hornbean (ironwood) and red cedar were also used. Bow strings were made from twisted bear intestine or from woodchuck hide. Arrowheads were usually made of flint, but bone was also used.

In spite of a somewhat sophisticated weaponry, the killing power and range of the Eastern Indian's arsenal was still quite limited. Long and diligent stalks were necessary to get within effective range of an intended quarry. More often than not, an additional long episode of tracking was required after the animal was struck in order to find the wounded game, as there were few instant kills. Interestingly, even after acquisition of white man's firearms, most Indians were poor long-range shots despite legends to the contrary. It was still necessary for them to rely on their great skill of silent stalking and tracking, and the ability to conceal themselves in order to procure game.

Realizing that they could rarely track an animal right to where it slept, they paid almost as much attention to the trail ahead as they did to the ground below their feet. A thorough knowledge of the terrain and habits of the animals being pursued eliminated unproductive meanderings along the trail. Rather than doggedly following tracks, the hunter would go directly to points the animal was likely to pass, and pick up the trail again. This technique allowed considerable time and distance to be gained on an animal.

The Indians paid meticulous attention to wind currents as all good hunters must. They were aware of the phenomenon that on windless days cold air in the valleys was warmed by the morning sun and would rise carrying scents with it. Accordingly, in the mornings, they would hunt from higher elevations down towards the valley floors. In the evening, as the air became cooler, the process was reversed. Observations of the behavior of ground fog undoubtedly was responsible for this information.

The practice of rapidly tracking and pursuing an

animal until it reached the point of total exhaustion was common among Eastern Woodland Cultures. Relays of young, fleet-footed runners were formed to relentlessly chase a frightened animal. Knowing in advance the probable attempted escape route of the animal, fresh runners were posted along the way to carry on the chase. The exhausted animal, its fright draining its strength, eventually collapsed and was an easy kill. Being the opportunists they were, Indian hunters listened for the cries of a marauding wolf pack signaling a deer chase was underway. With the task of wearing the deer down already initiated by the wolves, Indian runners would take up the chase and claim the spoils in the end. In some eastern tribes, young, unmarried men were specifically trained to become runners. They were members of a sort of fraternity with strict rules of conduct, rigorous physical training, and much spiritual preparation.

Deer drives were effective in pushing a deer into a situation of distinct advantage for the hunter, such as a promontory of land extending into a lake or river. Here the deer was forced to plunge into the water, and the pursuit was continued by Indians in swift and agile birchbark canoes. Once overtaken in the water, the animal was readily dispatched with the sharp edge of a canoe paddle swung against the base of the animal's skull. Lances and, as some evidence suggests, even harpoons were also used. Chance encounters with deer or moose voluntarily cross-ing deep water occurred, and these animals, too, were intercepted and slaughtered.

Human scent was just as effective in driving deer as was actual sight of a line of advancing drivers. For this reason, the day for the drive was carefully selected on the basis of wind direction and weather conditions. Intent-ionally set fires were utilized at strategic points to help herd the frightened animal towards its rendezvous with death. It is a quirk of animal behavior that deer are particularly

terrified by the smell of scorched flesh. Indian drivers often enhanced the effectiveness of their own dreaded human scent by carrying pieces of burned meat on sticks.

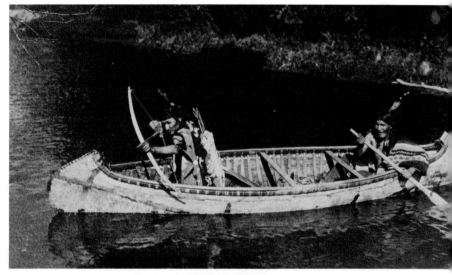

Smithsonian Institution — Photo by Roland Reed circa 1900

Chippewa men pursue a deer that has been driven into the water.

In deer drives, scent and visibility were purposely made obvious to the quarry; in ambush tactics every attempt was made to conceal both the sight and smell of the hunter. Indian hunters were astute observers of the natural world, and understood animal behavior well. They knew places frequented by deer and moose such as favorite watering areas, mineral licks, bedding areas, and scrapes. They also understood how to utilize these areas to their benefit by properly placing blinds where effective close-range attacks could be carried out.

In another method that was really a combination of stalking and ambushing, the blind was actually carried to the deer themselves. This involved wearing a tanned deerskin, with antlers attached, and moving into the center

By draping themselves with a deer cape, Indian hunters were able to make a closer approach to their quarry.

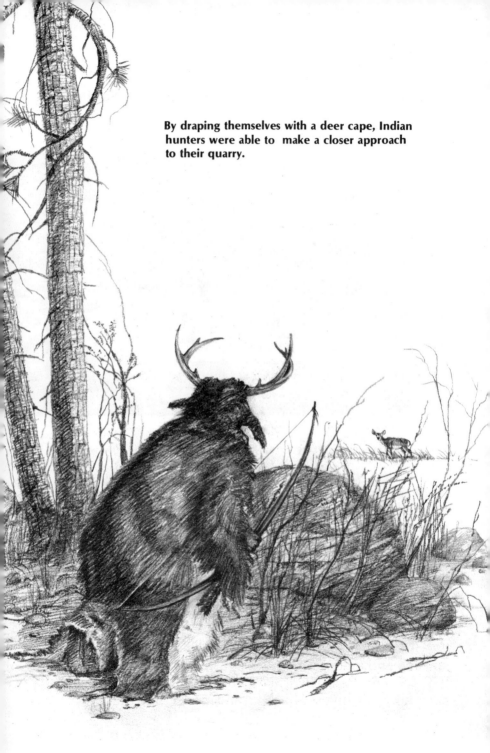

of a feeding herd of deer. Ethnologists have long recognized that animals of a given species recognize each other by prominent parts of the body rather than by the animal as a whole. Characteristic postures and gaits also play an important role in this animal identification. Tribes as diverse as the Iroquois of the East and the Maidu of central California took advantage of this to get close to deer. Walking in a crouched-over position with their bow and bundle of arrows dangling down in such a manner as to resemble forelegs, the hunter advanced when the deer's head was down browsing. Approaches from the side took advantage of the deer's limited peripheral vision, and prevented too close scrutiny. A direct rear approach would frighten the timid deer and was avoided. The hunter's chest was painted white to correspond with a deer's underside.

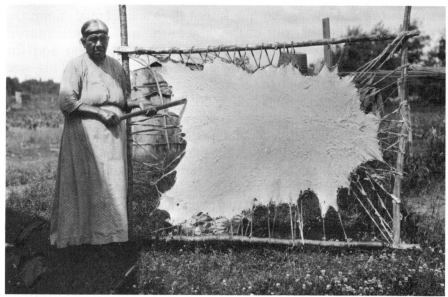

Milwaukee Public Museum

An Ojibwa lady scrapes a stretched deer hide with a section of a gun barrel flattened on one end.

This technique was best employed during the rut. A little grating of bow and arrow shafts together simulated the sound of bucks intermeshing their antlers, and might bring a buck deer a few steps closer if judiciously used at just the right moment.

A variation of this technique was used by the Chickasaw and Choctaw of the middle gulf region, and probably eastern tribes as well. They would use a deer head on their fist, much as one would work a hand puppet, to imitate the feeding movements of deer, and hence coax the animals closer. Deer heads used in this way consisted of a cured skin and the frontal bone of the deer's skull with the antlers attached. The antlers were meticulously hollowed out to make them lighter. The cape was stretched over split cane hoops to give it form, and a hand-hold extended from the inner surface of the frontal bone.

The reflexes of some game animals, particularly white-tailed deer, are so quick that they will literally "jump the string" or get out of the way in the minute time interval elapsing between the twang of the bowstring and the instant that the arrow arrives at its mark. This was especially true in the close-range stalking that the Indians of the Eastern forests had to do. Tufts of downy feathers tied to the bowstring acted as silencers. Characteristically, owl feathers were used because this predatory bird was known to be a silent hunter on the wing, and it was hoped that the owl's hushed manner would become a property of the bow.

Certain types of ambush hunting had their effectiveness enhanced by the use of animal calls. A wooden device with a hole cut in the center that was partially covered by a thin piece of fish skin would, when blown on, emit a sound like the tremulous bleating of a fawn. This sound attracted does as well as many predators. Sounds that represented no specific animal or bird, such as scratching, soft whistling or quiet tapping, often piqued the curiosity of game, and brought them to within range of the Indian hunter.

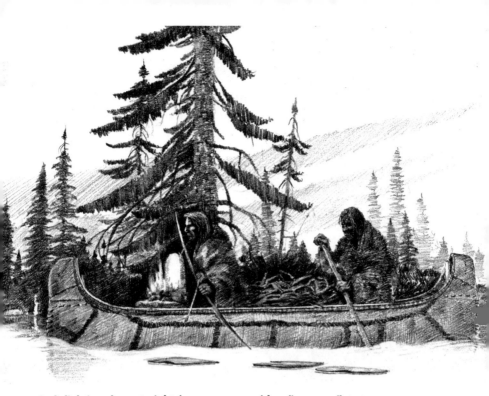

Jack-lighting deer at night from a canoe with a fire on a flat stone placed in the bow was commonly practiced throughout the Great Lakes area.

Several Great Lakes area tribes hunted deer by "jack-lighting" after dark. A fire was built on a flat stone placed in the bow of a canoe. Another flat stone placed upright acted as a reflecting shield behind the fire. The canoe was silently paddled about the shore of a lake while the hunter crouched behind the reflecting stone so as not to be temporarily blinded by the light of the fire. Once located, deer were intrigued by the strange light, and stood motionless staring into it. This resulted in a temporary blindness, and allowed close approach of the canoe for an easy shot. Even those deer that were not transfixed by the light and fled would, as often as not, become confused by their own leaping shadows and run towards the hunter. Hand-carried torches permitted essentially the same type of hunting on land. Torches were fashioned out of pitch-

laden pine knots on the end of a limb which served as a handle, or of a green stave split at one end to hold a bundle of folded birch-bark strips.

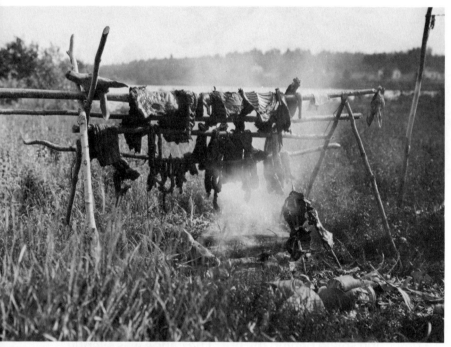

Milwaukee Public Museum

"Jerking a deer" Notice unskinned doe heads on each end of the pole frame and over the embers.

Snares attached to bent saplings, or "springpoles," were set on deer trails and sprung when a delicate trigger mechanism was activated. A simpler and more effective deer trap, however, consisted of a brush barrier across the game trail. Deer effortlessly leaped across this obstruction, but waiting for them on the opposite side was a sharpened stake set in the ground on which they landed and became impaled.

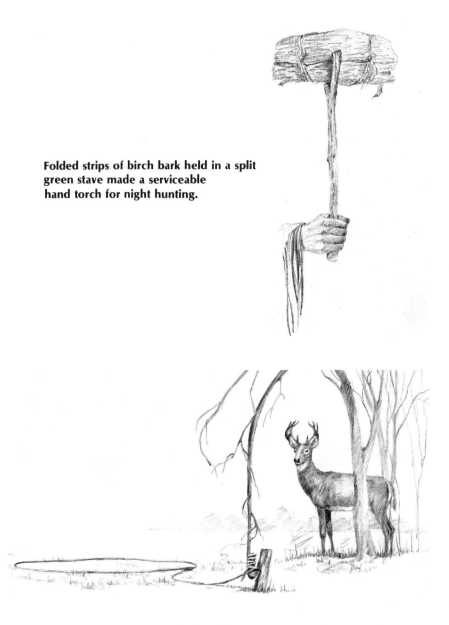

Folded strips of birch bark held in a split
green stave made a serviceable
hand torch for night hunting.

Springpole snares were set in game trails.

It is uncertain just how often moose were killed by Woodland Culture Indians prior to the advent of modern weapons, but those periods in which the animals were vulnerable were taken advantage of. One such period was the rut, when the moose's libido is at high pitch. Moose, particularly love-sick bulls, were called into effective range during the rut with a series of amorous "grunts" amplified by a birch bark megaphone. Calling was frequently done either concealed on the shore of a lake or from a canoe. The final "come-on" was elicited by filling the moose call or a canoe bailer with water and allowing it to slowly and noisily trickle back into the lake. This sounded to the bull moose like water dripping off the muzzle of a cow as she lifted her head from eating under-water plants in the lake, or better yet, like the cow moose urinating in the lake and thus indicating her willingness. Such sensual "moose talk" usually sufficed to lure the bull from his cover in a final rage of passion. When calling from a canoe on the lake, the shortsighted moose frequently mistook the craft with its hunter as the object of his intentions, and some very close encounters resulted.

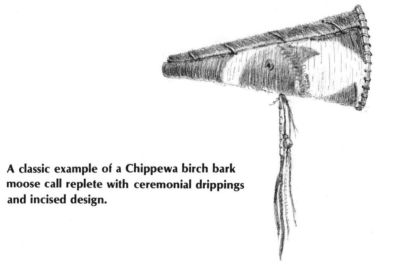

A classic example of a Chippewa birch bark moose call replete with ceremonial drippings and incised design.

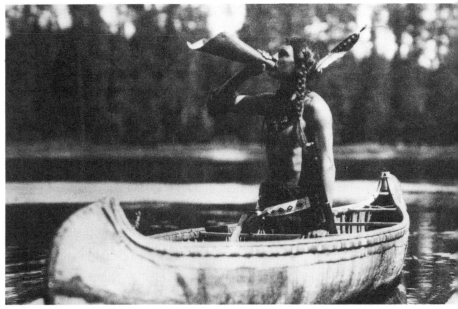

State Historical Society of Wisconsin — Photo by Roland Reed.

An Ojibwa hunter uses a birch bark megaphone to call moose from his canoe.

The shoulder blade of a moose was often used in calling to supplement the birch bark-megaphone type of call. The scapula of a female moose was favored for superstitious reasons, or perhaps because that of the bull was just too heavy to carry around. After its dorsal ridge had been trimmed off, the scapula was hung up to dry. The altered shoulder blade was rubbed against a tree, mimicking the sound bulls often make during their sham fights with a tree or bush during the rut. A fresh bone could be used if necessary, but these lacked the desired qualities or resonance. When hunters found a clump of bushes which had been raked or scraped of their bark, or when fresh spoor was sighted, they would use their scapula. Long periods of silent listening always followed each use. Moose calls were traditionally hidden from women and children for

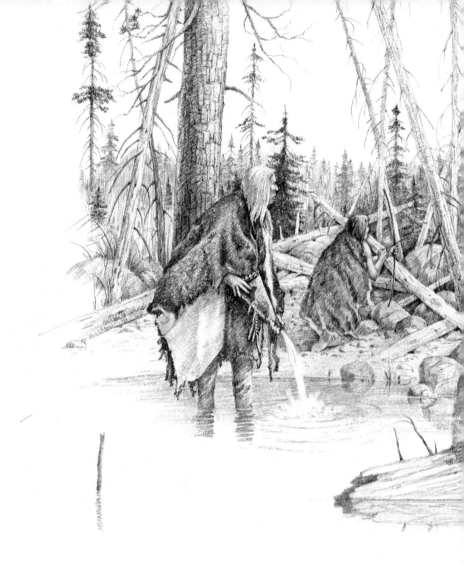

fear of ritual contamination. Some of the birch bark calls were elaborately decorated with ceremonial drippings and incised designs in the cambium layer of the bark.

The Penobscot preferred to hunt moose when there was a heavy snow cover. At such times, their webbed footgear gave them a distinct advantage in mobility. The strategy was to wound a moose with a spear or arrow when it was first sighted, usually in its wintering yard, where there

A bull moose is lured to within bow range with amorous grunts made with a birch bark moose call.

was not much snow. The wounded animal would flee its sanctuary, and to follow it across deep drifts was a simple matter. The hunter got in another shot whenever possible and, all the while, drove the animal toward areas of deeper snow. Eventually, the moose, with its great weight and sharp hooves, would flounder and become easy prey for its snowshoe-clad tormentors.

It is legend that primitive man from diverse cultures across the continent looked upon the bear with feelings of veneration and awe. Perhaps it was the close resemblance to the human form when standing on its hind feet that evoked this brotherly reverence towards the bear. Nevertheless, they were killed for their meat, hide and the claws which were used to make highly prized necklaces. For some reason, few good descriptive accounts of bear hunting have been preserved. Being a semi-hibernator, black bears were best subdued in their winter lairs. In the hardwood forests, standing hollow trees were favored as dens. When suitable trees were not available, likely denning sites included the area beneath a ledge of rocks, under the roots of a partly fallen tree or in a rocky crevice on a mountainside. Dens were usually on a high elevation with a south-facing slope. Such a location stayed clear longer in the autumn, opened earlier with the melting snows of spring and afforded adequate drainage. Likely denning sites were located and memorized during the Indian hunters' foragings in the woods throughout the year, and were then re-visited in March or April. Fresh claw marks on the trunk of a tree indicated current habitation. The bear was routed from its quarters either with poles thrust into the den or by smoke. Aroused from a deep sleep, the bear was stuporous and sudden exposure to bright sunlight was blinding at first. Under such conditions, the black bear would not make a very formidable adversary and was easily killed.

Baiting may have been used in hunting black bear, and there are sporadic reports of dogs being used by the Creek Indians although this may have been solely in the post-contact era.

Elk once inhabited the East in mountainous sections of Pennsylvania, West Virginia, and Ohio. The last wild elk reported in West Virginia was seen in Pocahontas County in 1845. There was also a species of woods buffalo found in

the Eastern forest. Only scant information remains, but it is logical to assume that these animals were hunted by the same general methods of driving, stalking, and ambushing that were successfully employed on other big game animals.

Small Game Hunting

The larger game animals provided most of the staples necessary for existence, but many small mammals were also taken both for food and for the use of their pelts. Otter fur in particular was valued as a covering for bow cases and quivers, for medicine bundles and as hair wrappings. Beaver hunting was mostly an ancillary undertaking prior to the influence of white fur traders. An insatiable demand for beaver fur in Europe in the 1600's and 1700's spurred traders in their quest for riches through the fur trade. A heavier beaver kill by the Indians was encouraged, and more efficient methods were devised. No longer was the shooting of a solitary beaver or otter as it swam across a pond sufficient. Entire colony-decimating tactics were probably used on occasion before white contact, but not on the grand scale that was encouraged by the early fur traders.

Winter was the ideal time to hunt beavers, and this coincided with the time when their fur was at its prime. The first step in these brutally successful hunts was to locate all of the burrows or "washes" along the shore of a beaver pond that led up underneath the bank. This was accomplished by thumping the ice around the banks and thus sounding out the burrow when a change in pitch occurred. All the exits from any beaver house in the pond were also located. Since these were usually in deep water

The winter beaver hunt involved the whole tribe and all phases had to be closely synchronized for success.

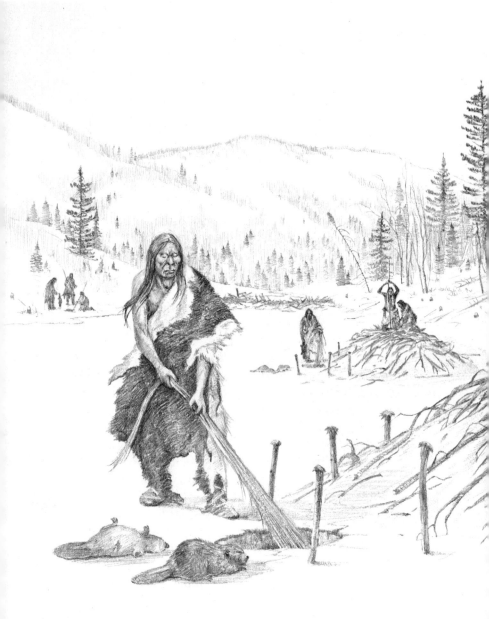

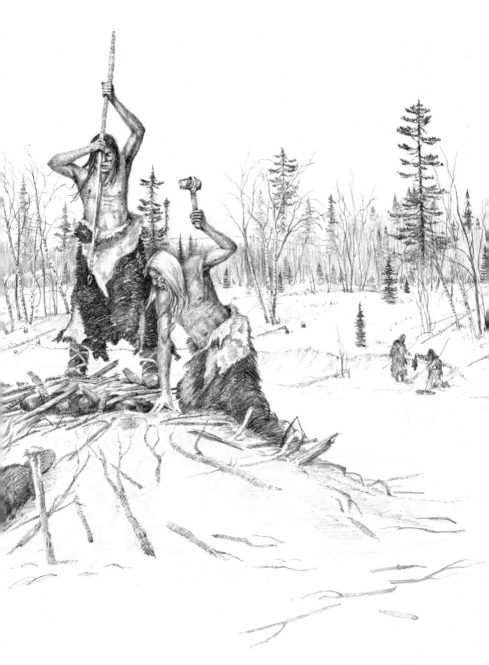

41

and were therefore more difficult to "tap out," they were often marked by stakes before the pond froze over. Any creek flowing into or out of the pond was picketed from side to side with stakes to prevent passage. A hole was then chopped in the ice directly over each burrow and at each lodge exit. A hunter was posted by each hole. When everyone was set to satisfaction, attention was turned to the main lodge itself. This was broken into from the frozen top, and the sticks and mud were jammed into each opening or exit. This was done to prevent the beavers from returning once they had been routed from the lodge. If several lodges were present in a single pond, they were all opened simultaneously in this fashion. The beaver fled via their usual routes to the burrows under the bank which they used for breathing places and as a sanctuary if they were disturbed at their lodge. It was then the duty of each hunter stationed at a hole to either snatch barehanded or to net any beaver that attempted escape beneath the hole. The startled beavers were jerked from the water at the critical moment as they passed beneath the hole, and were hurled onto the ice and rapidly clubbed. If the hunters had been thorough in locating exits and burrows, no avenue of escape remained, and the entire colony was annihilated. The young beavers were generally the first killed while older adults were more adept at avoiding the holes where hunters were stationed. Not infrequently, a wise old beaver might successfully obtain temporary sanctuary in a burrow among the roots of a large tree up under the bank. Dogs were then used to identify the occupied burrows, and the beaver resident was put to flight back through the passageways under holes in the ice.

To preserve the proper water level in their ponds, beavers kept a zealous watch over their dams and made periodic checks on the structure to make sure all was in order. The effect of any sudden fall in water level immediately brought beavers scurrying to the dam to make

necessary repairs. Indians took advantage of this and used it to the beaver's destruction. After purposefully destroying a part of the dam and allowing water to escape, the Indians would remain downwind and out of sight and shoot the little builders as they came to make their repairs.

Muskrat (*Musquash*) meat was relished even more than beaver meat, and their pelts were also useful. Eastern Woodland Indians used a muskrat call made with a device consisting of two pieces of wood, each about three inches (8 centimeters) long, mortised at each end. An opening was left in the center between them, and a shred of birch bark was fastened through the middle. Blowing through this device produced a resonant buzzing which resembled the call of a muskrat. By paddling their canoe along the shore of a lake, or still sections of a river where muskrats were plentiful, and working their call, Indians lured muskrats out from the bank to the canoe. The rats were then killed by a blow on the head with a canoe paddle. This call apparently worked so well that occasionally a muskrat was so deceived that it would try to clamber up into the canoe, evidently mistaking it for a log.

This method of hunting required two hunters in the canoe for best results, one to work the call and one to swing the paddle. It was necessary to stay downwind and to remain as motionless as possible. All the communications that were needed between hunters were accomplished by a mere shake of the canoe or a slight nod of the head.

The muskrat call, though simply devised with two pieces of wood containing a piece of birch bark or fish skin, was effective in luring muskrats to a close range.

Muskrat house construction was not unlike that of beavers in basic design except it was on a smaller scale and utilized grass and mud instead of the heavier limbs and small trees incorporated into the beaver lodges. The interior of the little mud-cave house was a hollow saucer-shaped area elevated just above the water level. The entrance was underwater. In the winter, a muskrat family would huddle close together in this area for warmth, often one on top of another. As soon as the ice was solid enough to support the weight of a hunter, a form of winter muskrat hunting began. After quietly approaching the muskrat house with spear poised, a mighty thrust was made blindly through the center of the lodge. If a rat was pierced, its wriggling was felt through the spear handle. The hunter maintained pressure against the spear shaft to keep his quarry pinned while the mud and grass of the lodge was torn away. The muskrat was then grabbed by the tail, removed from the spear and knocked against the ice. Not infrequently, the spear passed through two or even three of the muskrats in one stroke.

The crossing of a fresh lynx track in the wilds would always precipitate a chase. As soon as the lynx realized that it was being followed, it would climb a tree. If within bow range the cat was simply shot. If the animal was higher up, the tree was felled. As soon as the tree began to totter, the Indian ran towards the line of fall to be on hand to club the lynx as soon as it crashed to the ground. Most lynx however were caught in snares. The noose was set in a likely place, and the standing portion was attached to a light toss pole. Frequently, a rabbit skin with the head attached was stuffed with moss or snow and set in back of the snare so a lynx would spot this decoy and make a lunge through the noose for it. Once caught, the lynx became its own executioner by standing on the drag and pulling its head back. This attempt at gaining freedom only served to tighten further the noose about the lynx's neck, and

hastened its strangulation. Occasionally, a lynx took the drag in its mouth after being caught, and climbed a tree. This invariably would cause its death because once in the tree, the lynx would drop the stick. When it started to descend, the stick would catch in a fork and the lynx would be hung.

Most of the smaller animals inhabiting the Eastern and Northern forests were hunted by stalking and ambushing techniques. Squirrels were hunted with blunt arrows or stunners so less meat was spoiled. Grating two smooth round pebbles together mimicked the sound of a squirrel cutting a hickory nut, and was often successful in persuading a skittish bushytail to raise his head above a limb to peruse the situation. When a cat and mouse game was played between squirrel and hunter about the trunk of a tree, the old "hat trick" of tossing an object over to the squirrel's side of the tree usually worked in bringing the squirrel over to the hunter's side. The arrows used on small game such as squirrels, and also on birds, had the feathers, or fletching, applied in a spiral rather than the usual three straight vanes. This bushy fletching acted like a brake on the arrow, and shortened its maximum range so that it dropped quickly to the ground after a miss and would not be lost.

That simplest of traps, the pitfall, was probably man's earliest device for capturing animals by remote control. In their most primitive form, pitfalls were just a hole in the ground into which an unwary animal might fall and become trapped. As their construction became more sophisticated, camouflage tops, through which the animal would fall, covered the pits, and impaling stakes were sometimes planted in the bottom. Bait was used, but more often the pits were dug where the Indian trapper knew animals were traveling. Beaver and otter, for example, often crossed over land directly from one bend of a stream to another rather than swimming all the way. These trails made ideal

locations for pitfalls.

Animals ranging in size from the tiny weasel to the black bear were caught in deadfall traps. The support and triggering mechanism of the deadfall required three pieces of wood suitably shaped and notched. The horizontal member of the "figure 4" device had the bait either fastened around it or hung from its end. The size and weight of the trap depended on the specific animal for which it was set. The placement of the bait in relation to the falling weight was crucial so that a vital part of the animal, usually the head, was pinned. Shelters of bark or limbs were frequently constructed over deadfalls to capitalize on the urge many mammals possess to investigate any cubbyhole or cavern.

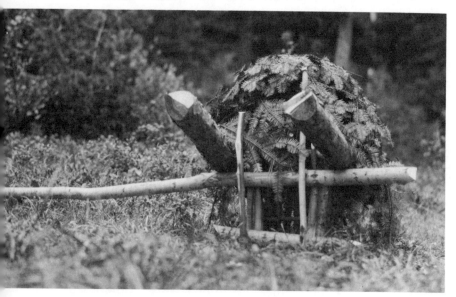

A typical Ojibwa deadfall trap.

An effectively deceptive trap for a fisher or mink was made in the cavity of a log, such as an old woodpecker hole. Two sharp wooden spikes were fixed to the rim of the hole so they angled up and into the hole. The trap was baited

Deadfalls, triggered via a "figure 4" mechanism varied in size according to the animal they were set for.

with a piece of fish. When a mink or fisher tried to steal the bait, they were able to squeeze their head past the inwardly slanting spikes, but were caught when they attempted to back out.

Opossums and porcupines, being relatively slow moving and sluggish were run down and clubbed. These easily caught animals served as good emergency rations during lean times. Young hunters were trained in killing woodchucks in preparation for larger animals and more important hunts later in life. The object was to get between the woodchuck and its burrow so that an interception could be made when the animal ran for the safety of its hole. This tactic also worked on badgers. A favorite method of dispatching this animal was for the hunter to run alongside or just behind the animal, and to jump high and land hard with both feet on the badger's back. This would break the badger's backbone if the hunter was quick and lucky.

Turkeys were lured into bow range with calls, and shot by concealed hunters. Passenger pigeons, now extinct,

once roosted in vast flocks in the Eastern forests. These somewhat dull-witted birds were mesmerized by torch light after dark, and enormous numbers of the birds were harvested by knocking them to the ground with long poles.

The Iroquois and Menomini were skilled at luring grouse into a snare by baiting it with grain. A shallow depression in the ground was baited with maize, and this was covered with a piece of elm bark that had a keyhole-shaped opening cut in it. A noose was placed at the apex of the hole. The grain at the wide base of the hole was easily obtained, but to reach those kernels at the top of the hole, the grouse had to stick its neck through the noose. The snare, tangled in the neck feathers, pulled taut when the bird withdrew.

Fishing

The rivers and streams of the eastern United States provided an abundance of fish for the Woodland Indians. They used traps, nets, and spears, but the greatest quantities were probably harvested by poisoning. The root of a plant called devil's shoestring (*Viburnum alnifolium*) was the most common source of poison, although turnip root and poke berry were also used. Devil's shoestring was a common plant growing on the sandy ridges bordering many eastern streams. Several large posts were driven into the stream bed, their tops extending just above the water's surface. The roots that had been gathered were then pulverized with a wooden maul on the tops of the posts. As the mashed roots fell into the water, they exuded their toxins, and the affected fish weakly finned on the surface, gasping for air. Women and children braved the irritating effect the substance had on their skin and waded down-

stream to gather the fish. Of course, poisoning techniques worked best during periods when rainfall had been light, and the streams were low and sluggish. This was usually in the hot summer months, and at this time the poison was further enhanced by the lowered oxygen content of the warm water.

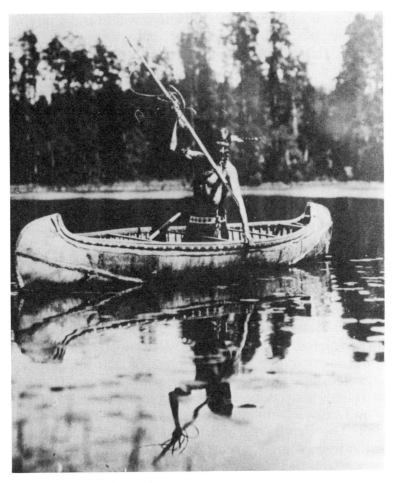

A Menominee Indian harpooning sturgeon on the Fox River in Eastern Wisconsin.

Certainly plant poisons accounted for the wholesale capture of most fish, but the lone sojourner in the Eastern Forest needed only his bare hands to produce a meal of fresh fish. By feeling gently under submerged ledges and logs, huge catfish could be located. If the angler's touch was delicate, the fish wouldn't flush, and then could be hypnotized with a soft, gentle stroking of its belly. Slowly, the Indian would work his hand into position and grab the fish by its gills. Many years later, old country poachers practiced this art in the same streams, calling it "noodling" or "tickling."

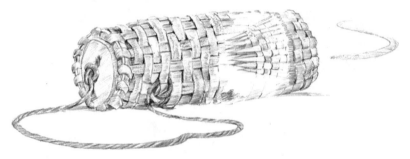

Basket traps such as these were set in rivers for migrating eels. The cut-away shows the conical entrance.

Eels are catadromous, meaning they live in fresh water, but spawn in the ocean. Most Atlantic seaboard rivers had an autumn eel run downstream toward the North Atlantic's Sargasso Sea. Weirs were constructed across rivers to herd the migrating eels onto lattice-work trays just under the water's surface. As they struggled across this shallow barrier, waiting Indians plucked them up and tossed them into a holding pit dug into the sandy bank. The Penobscot and Malecite, in particular, used basket traps with a conical-shaped mouth to catch eels in deeper water. These were baited with fish heads and weighted with rocks to sink them. Wooden floats attached by a line marked their location.

Wading the sluggish sections of streams with muddy bottoms, Woodland Indians located snapping turtles by feeling their backs with their bare feet. They deduced where the head was by the configuration of spines on the turtle's shell. This was important because while the turtle would not open his mouth underwater, his snake-like head was sure to come out snapping in every direction as soon as the animal was brought to the surface. They removed the entrails of the turtles through a cut below the vent, and then placed them on their sides around the fire where they were roasted in their shells.

No Indian cultural group had a more diverse terrain or a greater variety of animal life from which to extract their means of existence than did the Indians of the Eastern Woodlands. For this reason, few cultural groups had a greater repertoire of skills, weapons, or techniques at their disposal. The forest interspersed with open glades fostered an expertise in woodcraft and outdoor lore which made the Indians of the North and East America's supreme woodsmen.

Eastern Woodland Indian fish trap.

Index